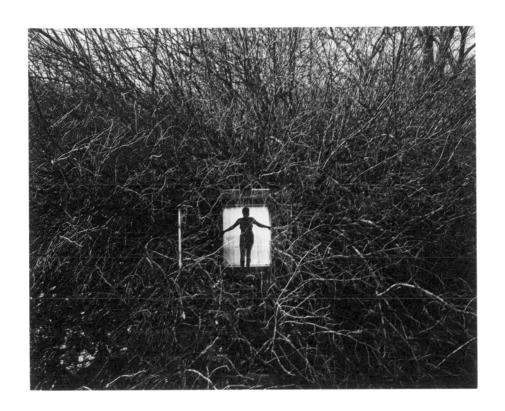

The Friends of Photography

Carmel, California

Callaway Editions

New York

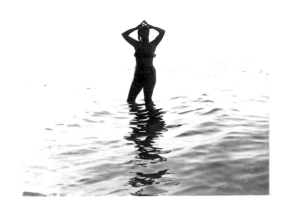

photographs by

Harry Callahan

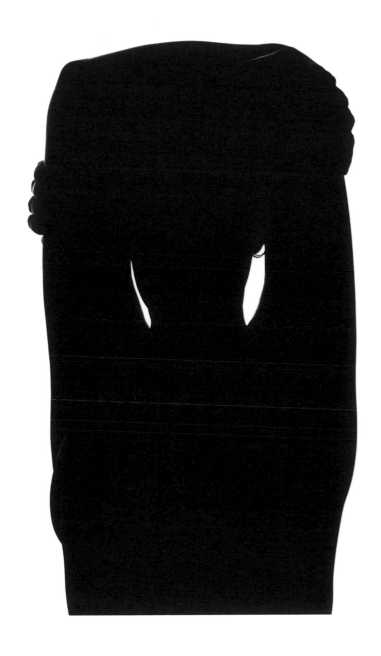

Edited and designed by

Anne Kennedy

Nicholas Callaway

Eleanor

1984

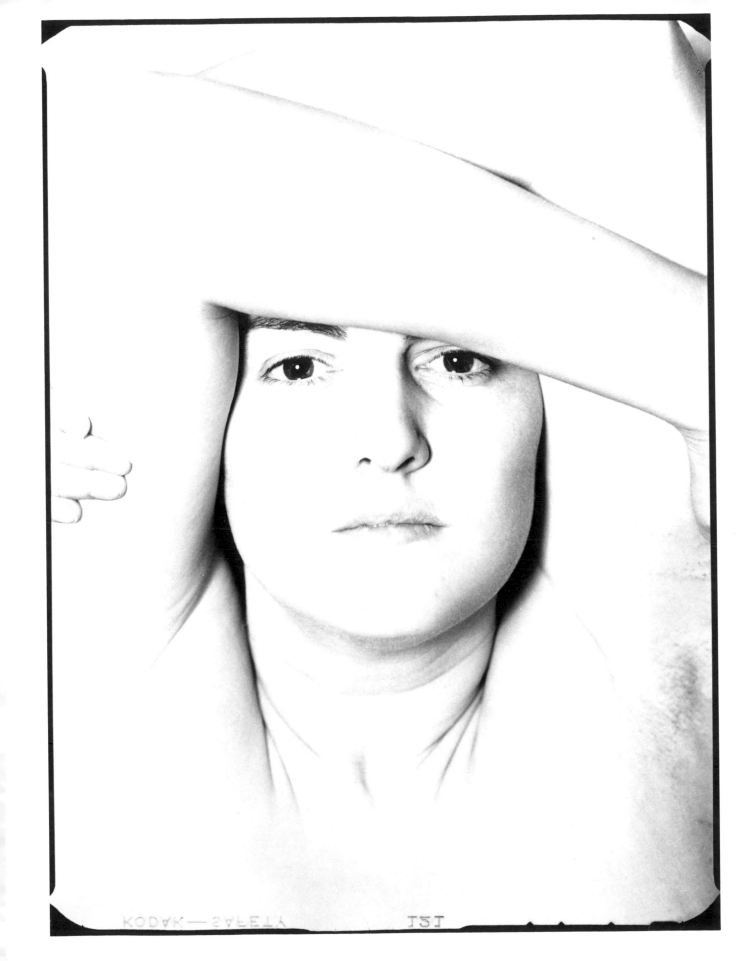

Acknowledgements

Harry Callahan's photographs of Eleanor are among his best-known and best-loved work. Until now only fragments of this series have been seen. With the publication of this volume, and its companion exhibition, the greatness of the Callahans' collaboration finally can be understood.

The publishers gratefully acknowledge the wonderful cooperation of Harry and Eleanor Callahan throughout the project. Our thanks are extended to Anne Kennedy, the co-editor and designer, who was important in the rediscovery of thousands of pictures that had been stored away and long forgotten. The form and content of this book are in large part due to her contribution.

The Callahans express their appreciation to Peter MacGill and to Carol and Arthur Goldberg, without whose generous help this joint venture would not have been possible, nor this book so beautifully produced. The support of James Enyeart and Terrence Pitts of the Center for Creative Photography in Tucson, Arizona, who organized the traveling exhibition, is most appreciated, as is that of David Travis, of the Art Institute of Chicago, where the exhibition opened in January of 1984.

Recognition must also go to Mary Alinder and to the staff of The Friends of Photography, particularly Peter A. Andersen, David Featherstone and Claire Peeps. Their role in the development and production of this book was crucial. Finally, we would like to thank The Meriden Gravure Company for their skillful and beautiful reproduction of Callahan's photographs.

Nicholas Callaway
Callaway Editions

James Alinder
The Friends of Photography

Harry and Eleanor

by James Alinder

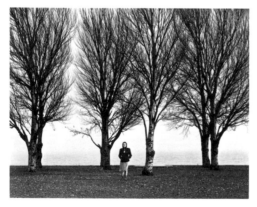

The most complete, personal, and impressive body of work in Harry Callahan's distinguished forty-year career is the series of photographs he made of his wife, Eleanor.

Other artists have photographed their wives over long periods of time: Alfred Stieglitz's extended portrait of Georgia O'Keeffe and Edward Weston's photographs of Charis Wilson are exemplary. The Stieglitz work attempts to define O'Keeffe's austere and intellectual personality. Weston did not intend to reveal Charis as a person, but rather placed her as a sculptural form in a carefully seen landscape. Callahan's highly-structured photographs unite these two approaches. Eleanor is seen as an individual, yet she functions as an icon and as a symbol of all women.

Harry studied engineering for three semesters at Michigan State University during the Depression era of the 1930s. Like many other students, he shed his strong religious beliefs when he became convinced that God was a myth, and his personal search for meaning in life assumed a different direction. Photography became his passion—his way of developing an understanding of life, and of communicating with the world.

Eleanor and Harry met in 1933 on a blind date, and were married three years later in Detroit, where they both worked for Chrysler. In 1938 Harry considered buying a movie camera, but finding it too expensive and the process too complex, he ended up with a Rolleicord 120 roll-film camera. He was self-taught, and in 1940 he joined the Detroit Photo Guild with his friend, Todd Webb. Weekends were dedicated to making new images. Weekday evenings Harry and Eleanor spent at home together—after dinner she washed dishes in the kitchen while he worked in the darkroom.

Harry began taking pictures during the heyday of the Farm Security Administration photography project, shortly after the first issues of *Life* magazine had entered American homes. It was a time when the documentary aesthetic was the model for most young photographers. Harry's interest, however, was in self-expression, rather than social change. Ansel Adams became his inspirational model after he heard a lecture by the older artist and saw his fine prints in 1941. He purchased an 8 x 10 view camera, and began to explore the remarkable image quality that the larger negative allowed.

Harry's reputation as a photographer grew. With no academic degrees, but with an exemplary portfolio of photographs, he was invited in 1946 to teach photography at Chicago's Institute of Design, where he was further influenced by his fellow artists and teachers. Encouraging students to find their own solutions and teaching by personal example, Harry became one of the great instructors at that innovative art school. He carried this reputation with him to the Rhode Island School of Design, where he founded the photography department in 1961. We know from Callahan's earliest photographs that his talent was significant; from the very beginning his vision was shaped by a continual reexamination of

his subjects. Harry worked with tremendous dedication, day in and day out. His goal was to make pure, perfect statements in which the subject itself revealed his meaning. He began photography with no preconceived ideas about what would make a good image. He was eager to try and willing to fail. Through thousands of exposures, he developed an elegant visual language that emphasized both formal and spiritual values.

His first concern was the landscape, at least what there was of it in Detroit—water, trees, and weeds. These landscapes were not grand vistas, but rather, more intimate spaces, places that derived their visual meaning from the artist's interpretation of detail. His photographs were highly organized, with clean, graceful lines. His prints often used limited tone and intense contrast to emphasize linear qualities. As he continued working, other themes became part of his explorations. Harry photographed vernacular architecture, revealing buildings as inhabited and humane. The city as a whole, however, was viewed by him as a monolithic maze.

Harry had been making significant photographs for several years before Eleanor became a primary subject in his pictures. She was photographed intensively from the mid-forties until the early sixties; their daughter, Barbara, was added to the cast after her birth in 1950. Eleanor is a private person who would never have considered modeling for another photographer. Yet she found Harry's photographs of her to be among his most expressive work; she did not think of them as pictures of her own body, but rather as works of art. Eleanor was always prepared to change to the role of model for her husband. If Harry found a situation visually stimulating, or if the light was irresistible, dinner was postponed and photographs were made. Occasionally, Eleanor suggested a pose, but decisions about background, props, and technical manipulations were his. While her availability and willingness were crucial to the making of the photographs, there is no doubt that Eleanor's most valuable contribution was as Harry's inspiration.

The variety and the range of techniques found in the Eleanor series match those in Harry's work as a whole. His extended portrait of her includes very straightforward images, as well as manipulated multiple exposures. Eleanor and

Barbara are often seen in familiar poses, in what Harry calls his "8 x 10 view camera snapshots", a blend of the personal and formal that has had considerable influence on recent generations of photographers. At times, Eleanor becomes a pure abstract shape, sharply delineated or silhouetted in soft focus. She may be seen in close-up with her head and hands filling the frame, or as a minute, but significant detail in a sea of black space.

Eleanor does not conform to any stereotype of female beauty. She is a real woman who ages, becomes a mother, and is always beautiful. In these photographs, she is a woman loved.

There is a warm human energy that radiates from these images. Through them we see a couple expressing the quiet intensity of their harmonious and lasting relationship. Harry's photographs of Eleanor will endure as well; they will stand among the most significant pictures in the history of the medium. They reveal the mystery, the beauty, and the force of love.

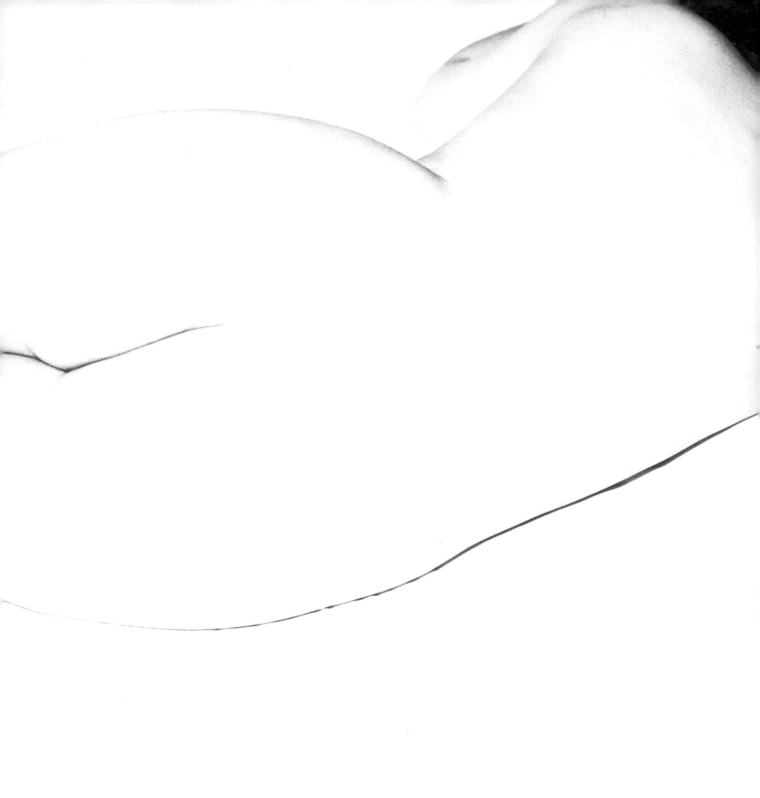

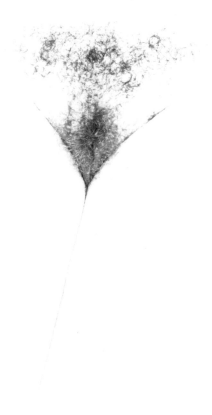

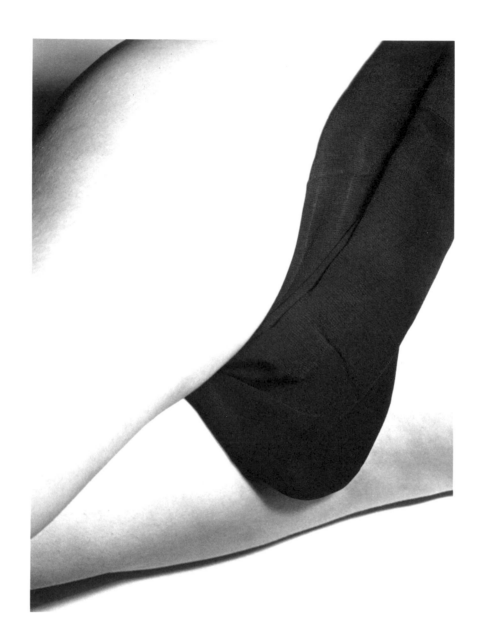

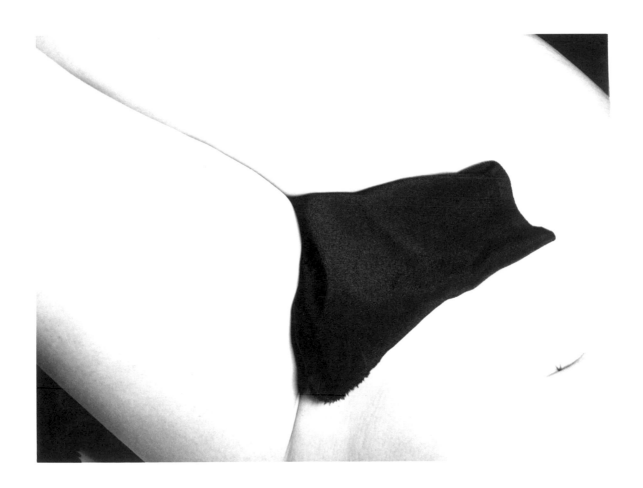

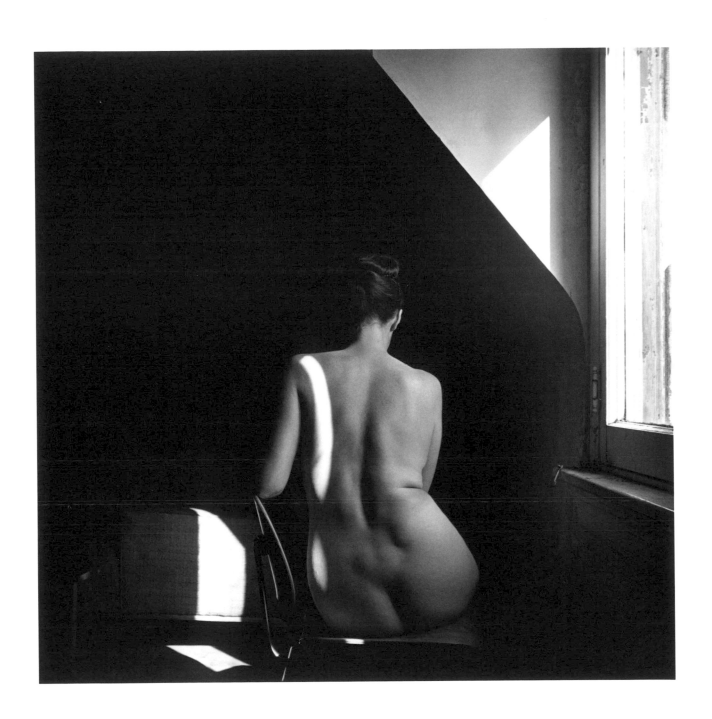

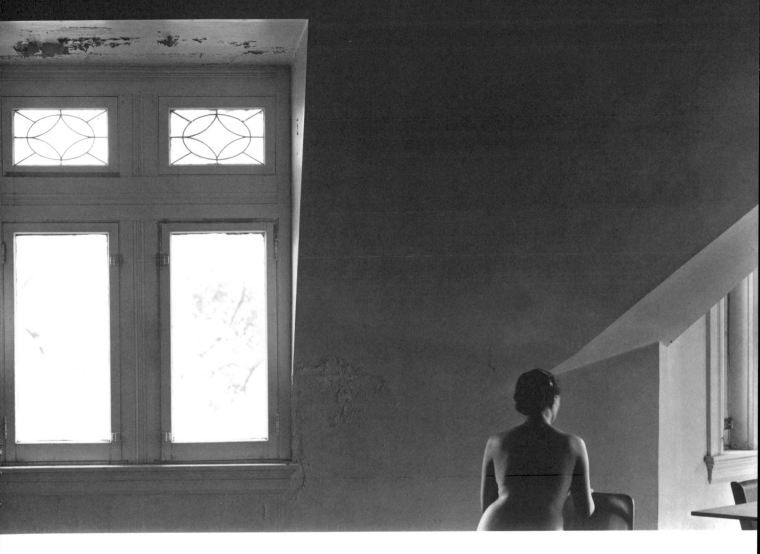

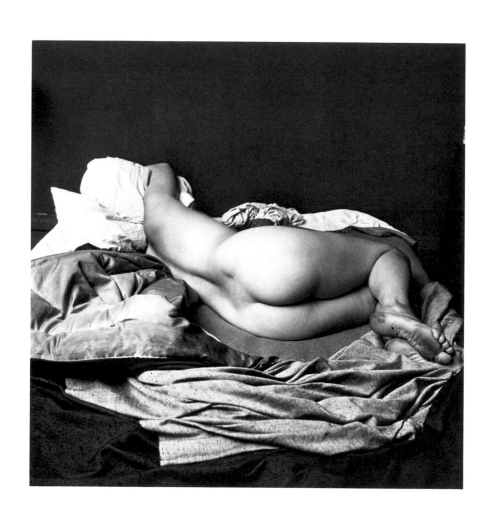

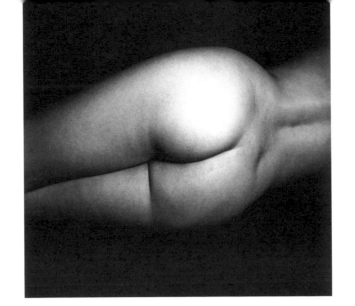

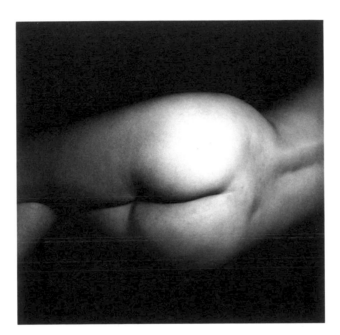

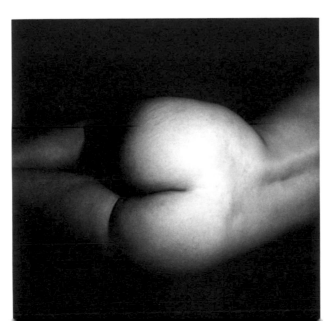

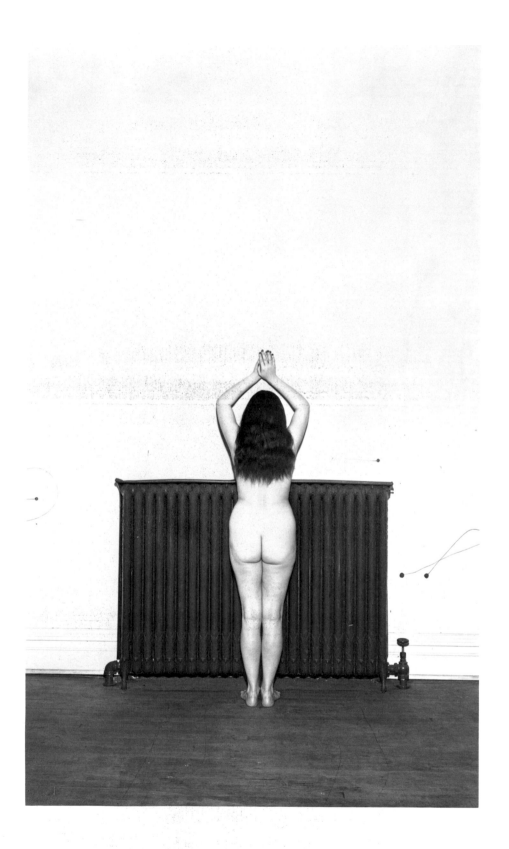

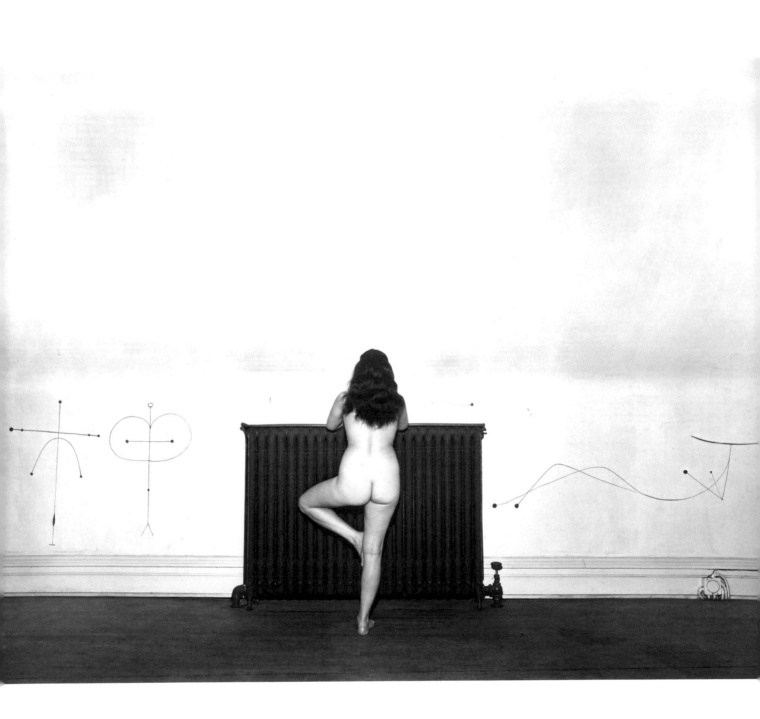

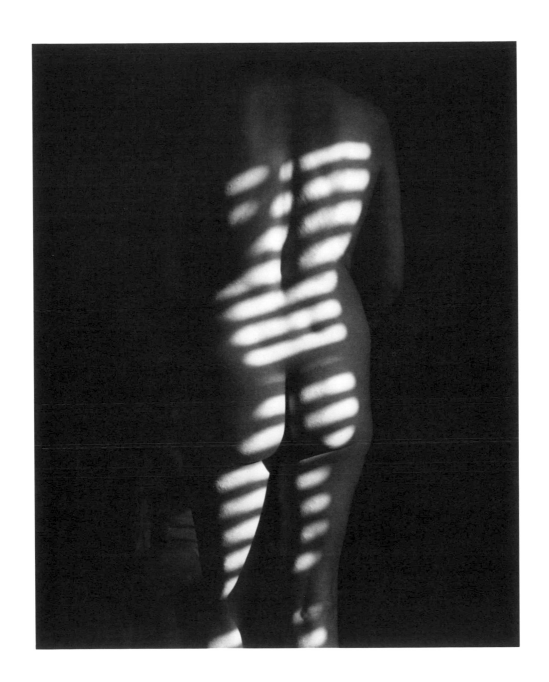

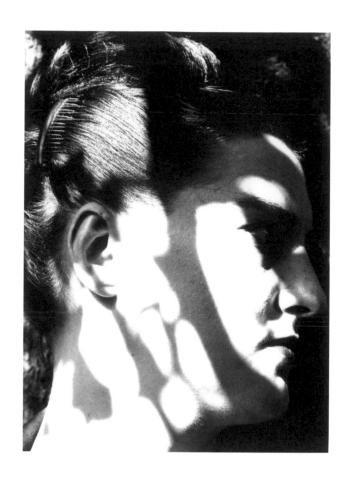

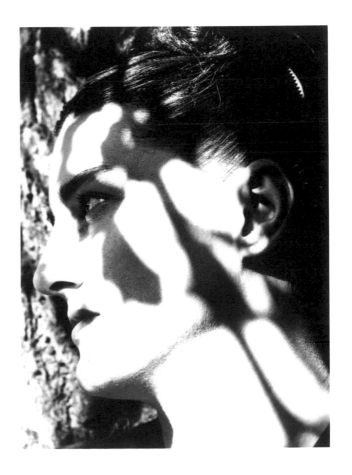

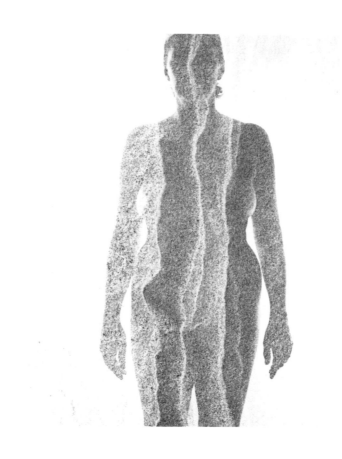

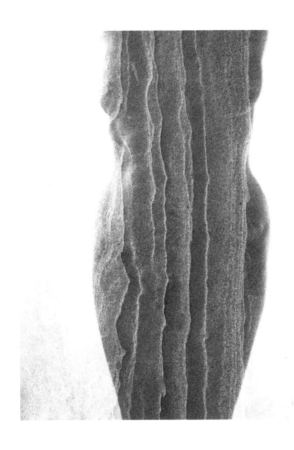

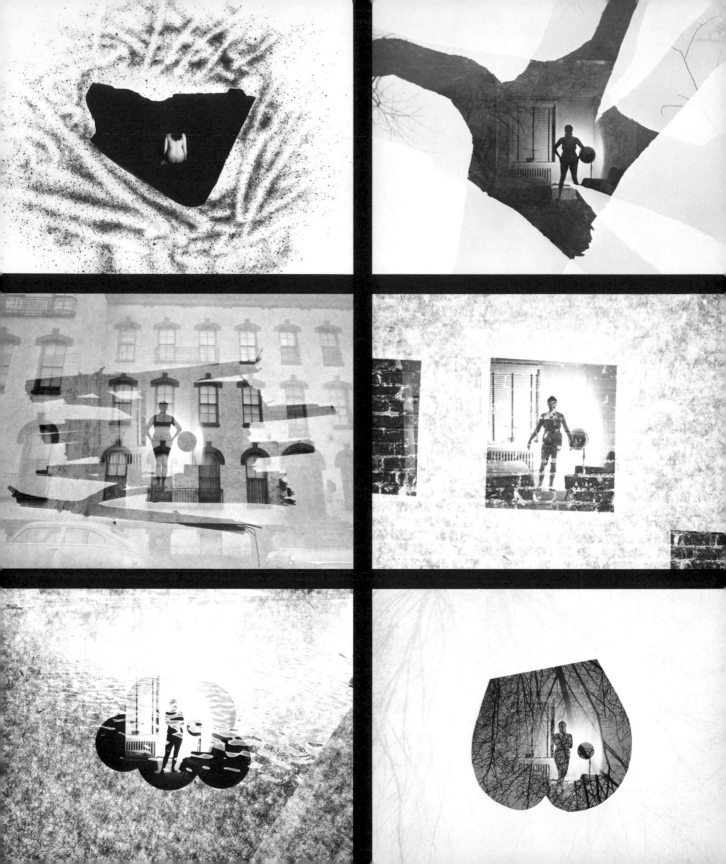

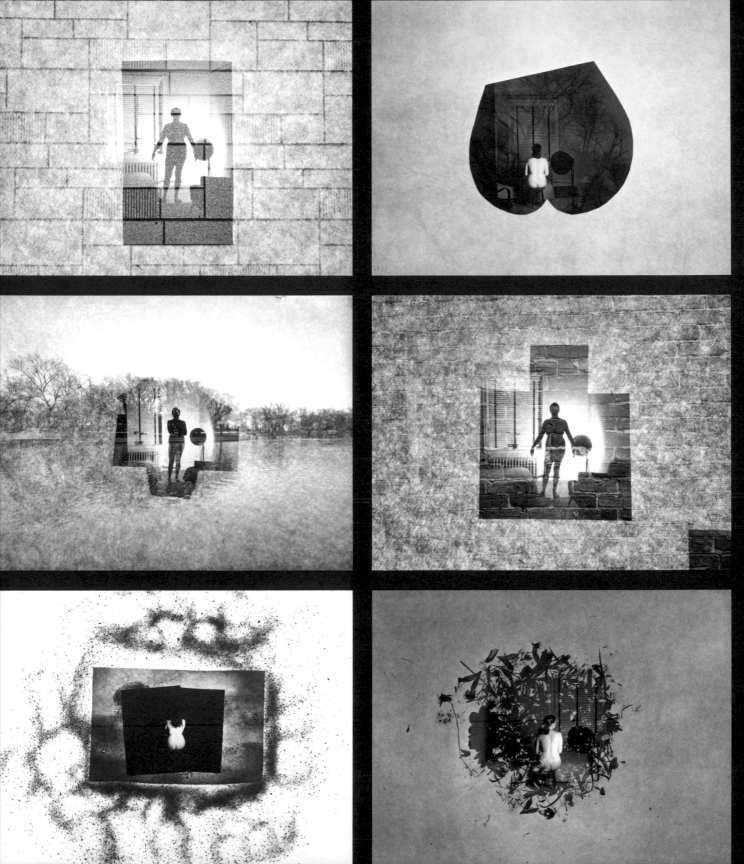

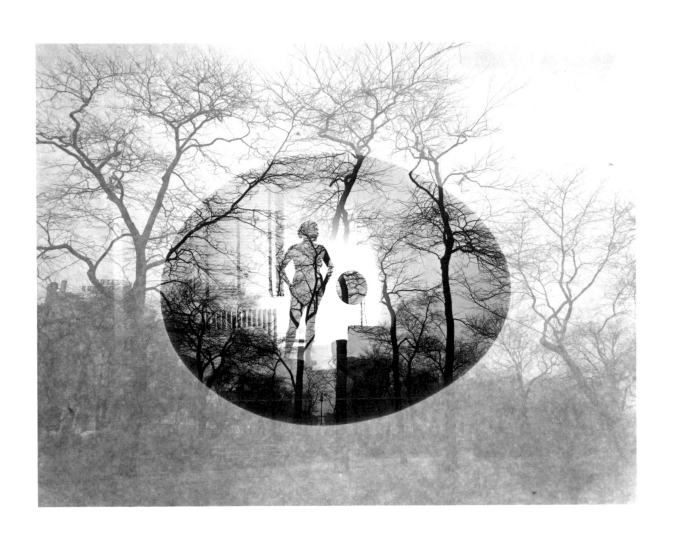

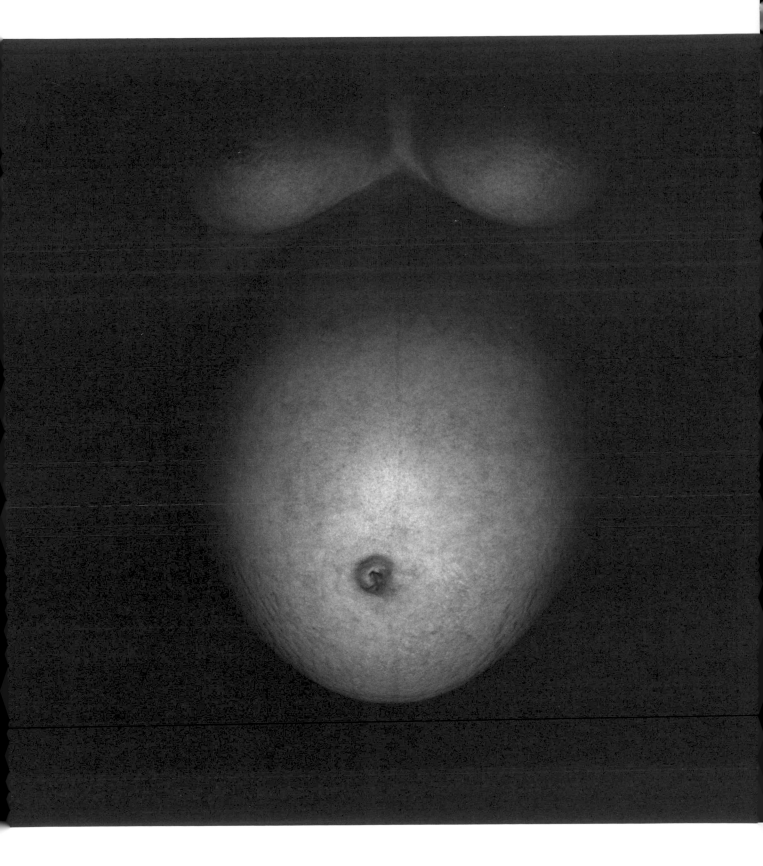

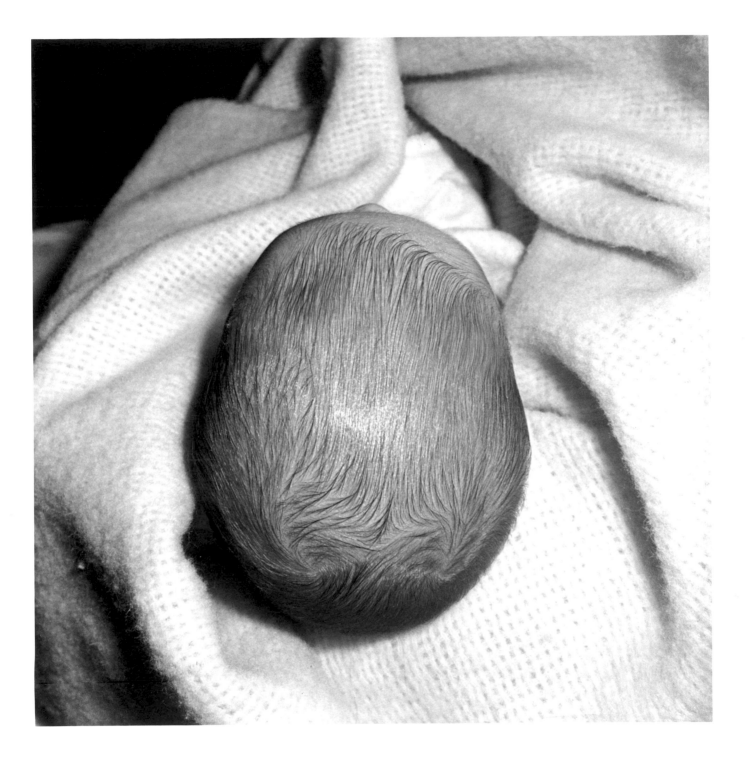

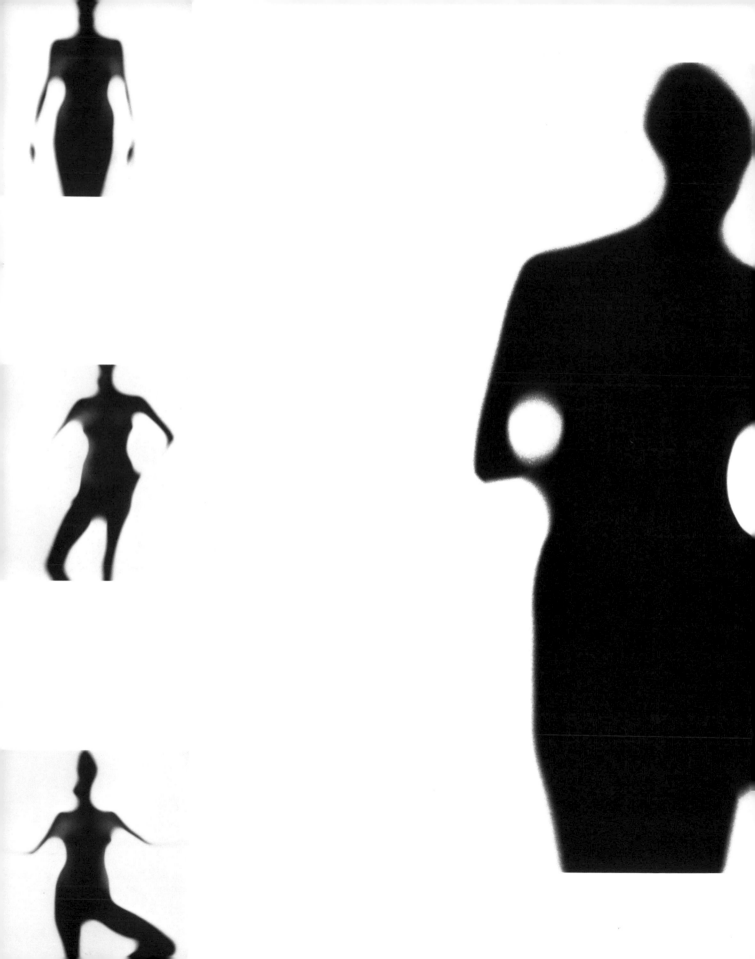

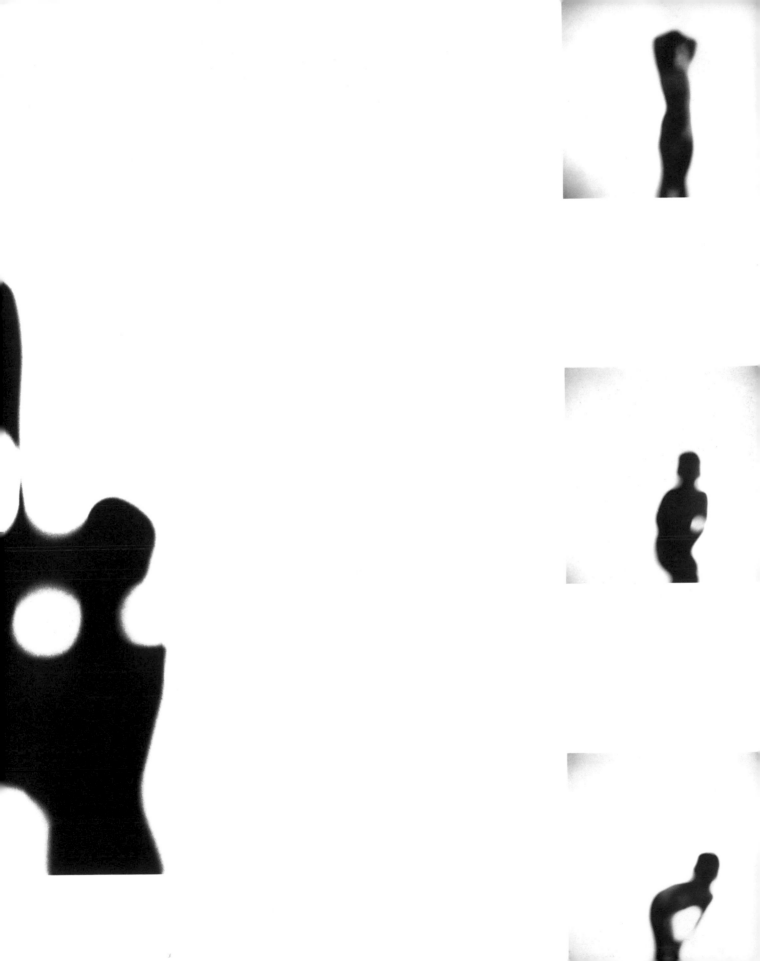

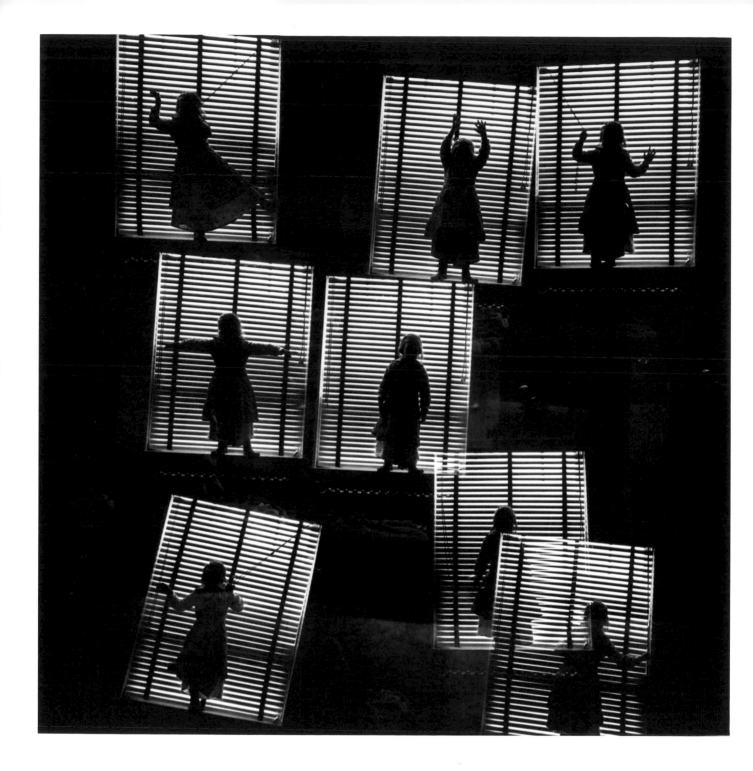

44

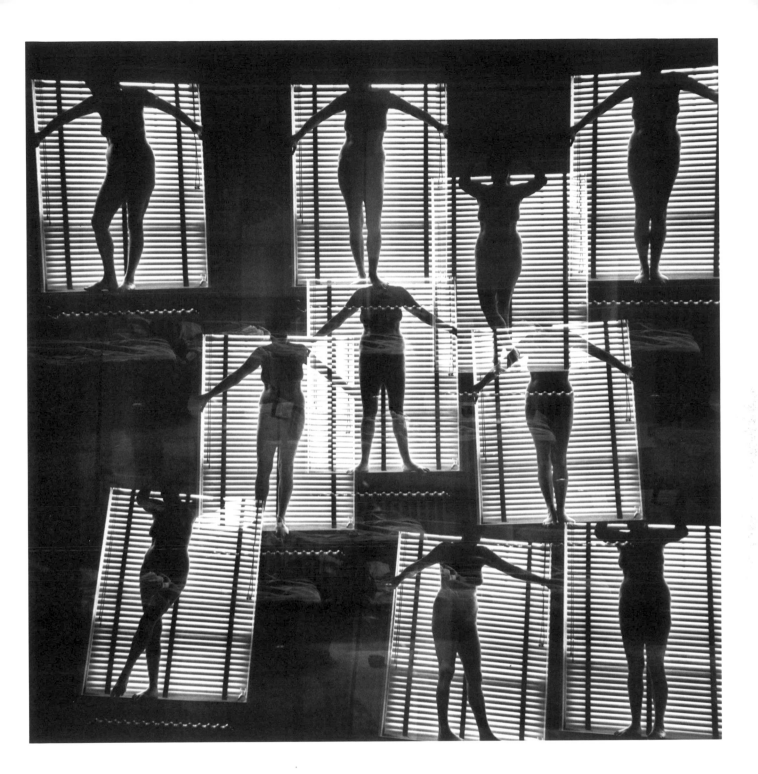

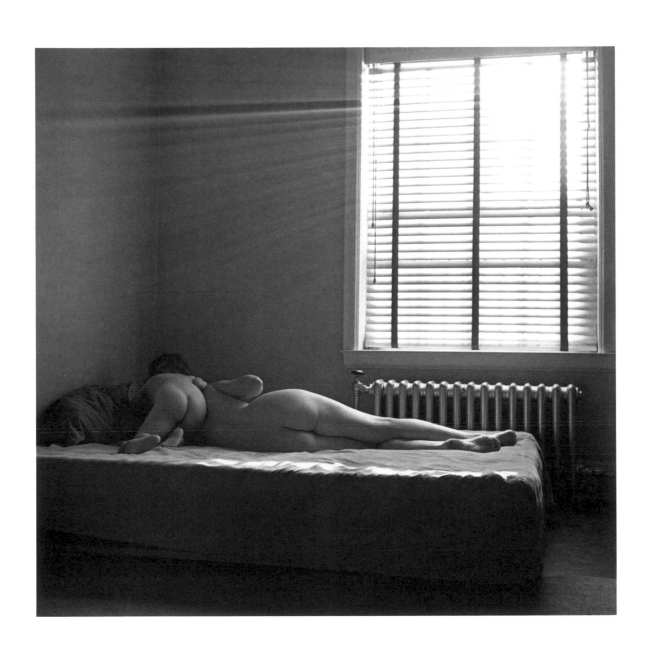

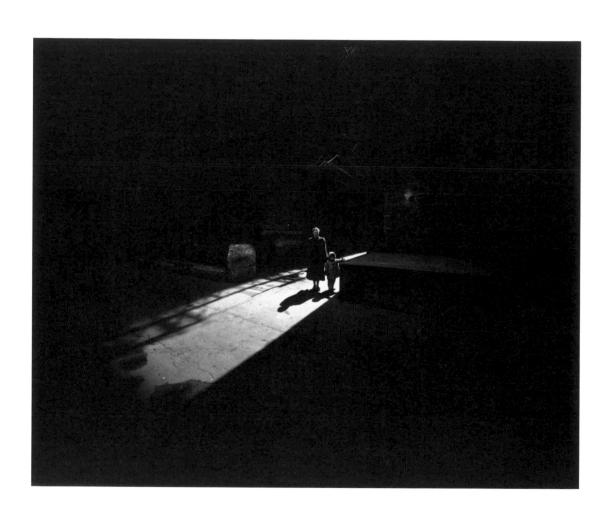

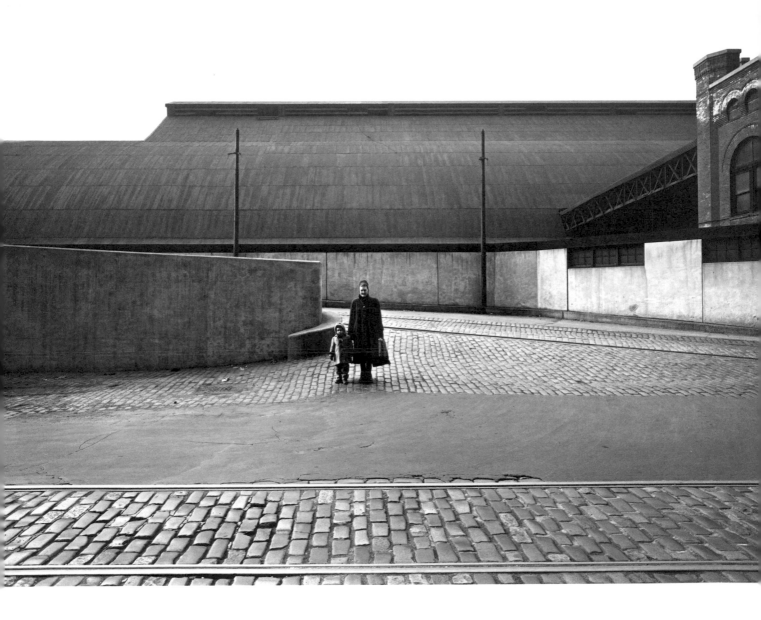

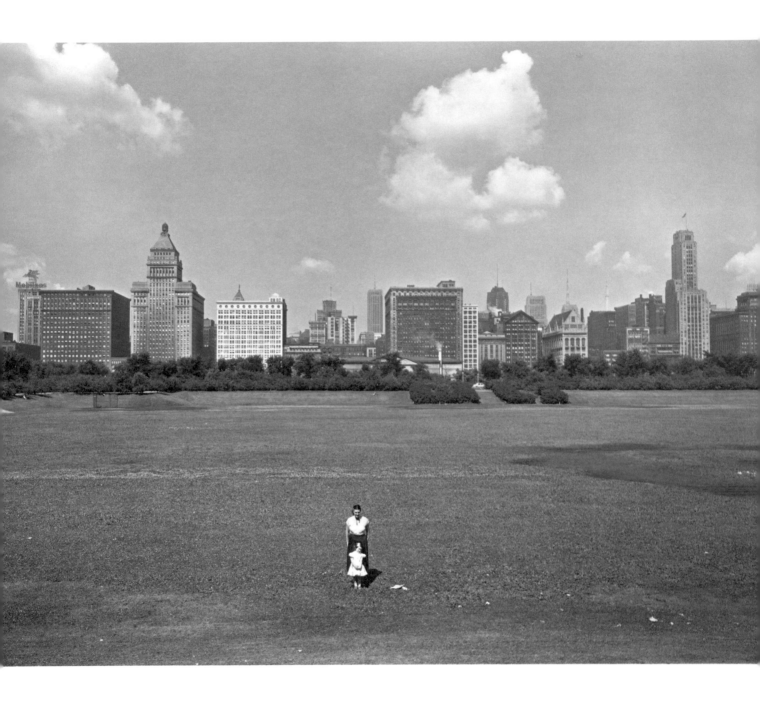

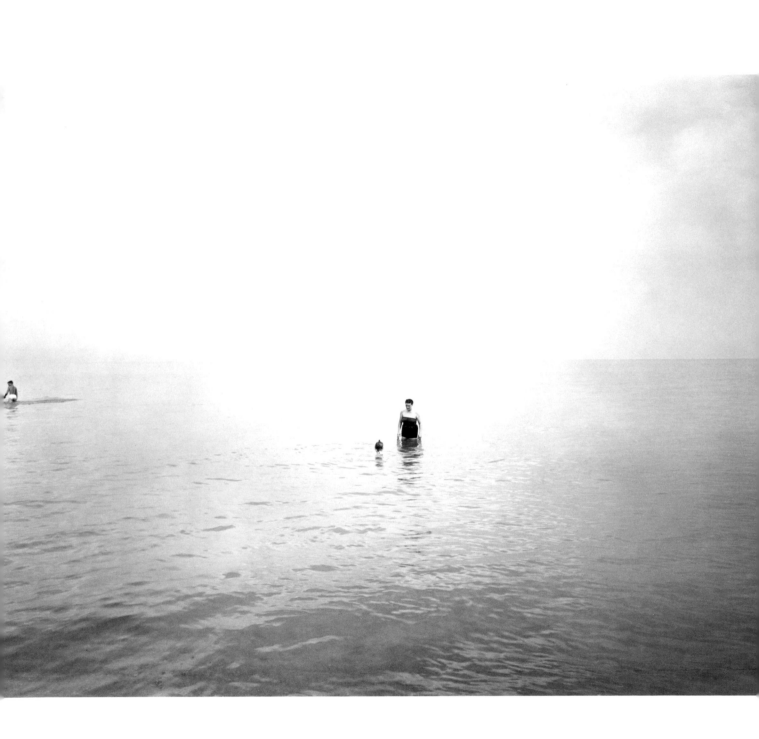

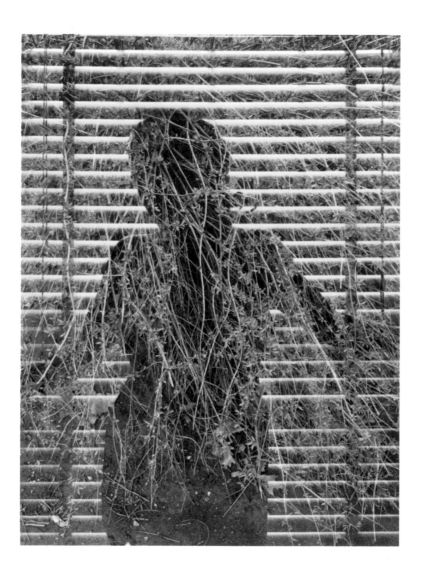

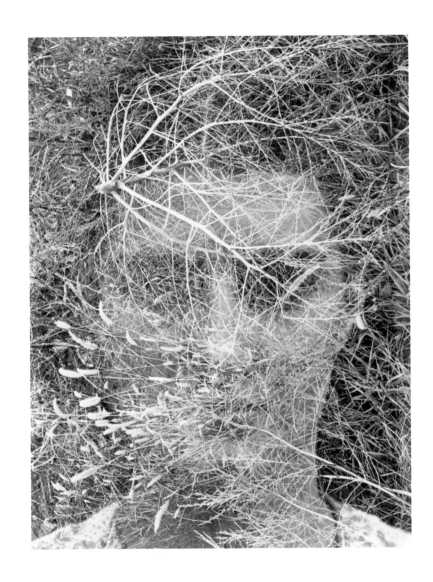

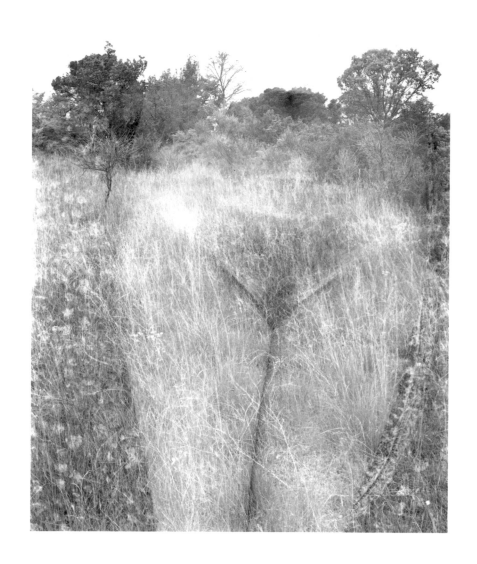

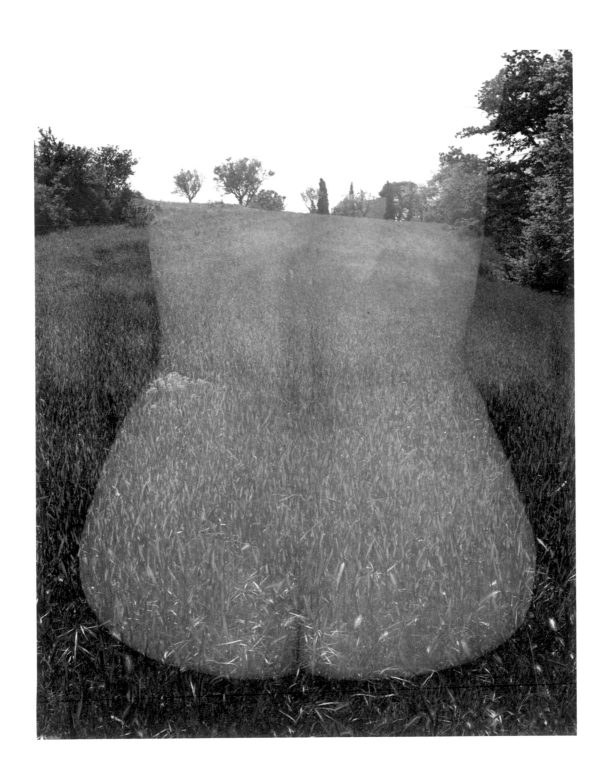

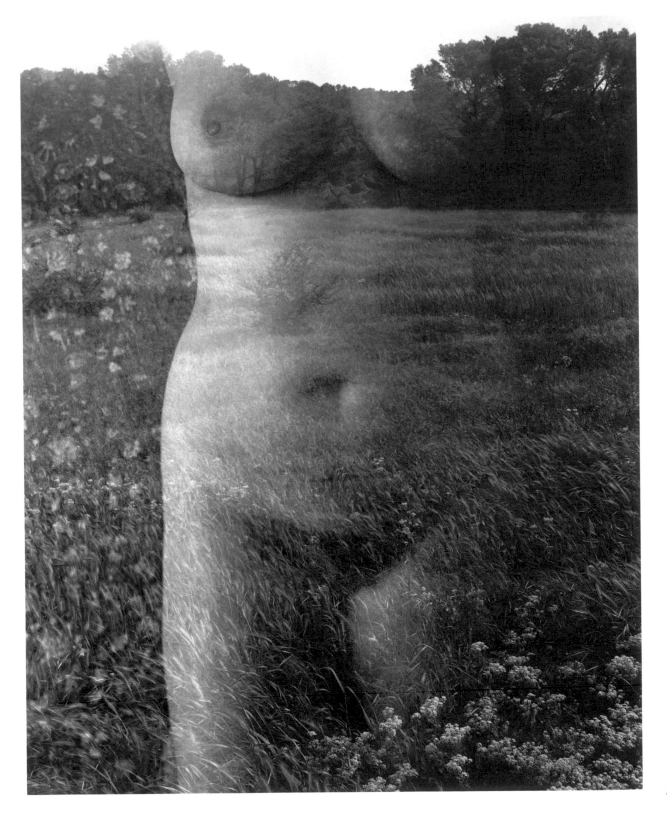

Harry and Eleanor Callahan: A Chronology

1912 Harry Callahan is born October 22 in Detroit, Michigan, to Harry and Hazel Mills Callahan; has two sisters, Alice and Marjory.

1916 Eleanor Knapp born June 13 in Highland Park, Michigan, to Leonard and Annetta Knapp; has two sisters, Lucille and Dee.

1933 Harry and Eleanor meet on a blind date set up by a school friend.

1934 After studying engineering at Michigan State University for three semesters, Harry joins the Accounting Department at Chrysler Motor Parts Corporation, where Eleanor also works.

1936 Harry and Eleanor are married November 25 in the Methodist Church in Detroit. They spend their Thanksgiving weekend honeymoon in Chicago.

1938 First strong interest in photography. Is self-taught; uses Rolleicord. Becomes a dedicated amateur with friend, Todd Webb. Creative drive leads him to photograph nearly every day for the rest of his life.

1940 Joins the Detroit Photo Guild.

1941 Strongly affected by Ansel Adams lecture and exhibition sponsored by the Photo Guild. Begins to use large format cameras and make contact prints. Makes first important photographs.

1942 Meets Alfred Stieglitz during week in New York City.

1944 Works as a processor in General Motors photo lab.

1945 Gives himself a six-month break to live and work in New York City. Meets Berenice Abbott, Beaumont and Nancy Newhall and others involved in photography.

1946 Invited by Arthur Siegel to teach photography at Moholy-Nagy's New Bauhaus, the Institute of Design in Chicago. First one-man exhibition at the 750 Studio Gallery in Chicago; forty prints sold at $5.00 each. Eleanor becomes Moholy-Nagy's secretary until his death later that year. They reside in Chicago for the next fifteen years. Important friendships develop with Hugo Weber, Mies van der Rohe, Aaron Siskind and Edward Steichen.

1947 Eleanor works as an executive secretary at Kemper Insurance.

1948 Steichen includes six Callahan photographs in Museum of Modern Art exhibition "In and Out of Focus."

1949 Appointed head of photography program at the Institute of Design.

1950 A daughter, Barbara, born February 6 to Harry and Eleanor. He initiates graduate program at the Institute of Design.

1951 Teaches summer session at Black Mountain College.

1953 Eleanor works as secretary to Charles Scholl of Dr. Scholl's shoes.

1954 Major exhibition at the Art Institute of Chicago. Receives Photokina award.

1955 Photographs included in "The Family of Man" exhibition and book.

by James Alinder

1956 Major exhibition at Kansas City Art Institute. Receives $10,000 fellowship from Graham Foundation to fund fifteen months photographing in Europe. Lives in Aix-en-Provence, France.

1958 Major retrospective exhibition at George Eastman House, Rochester.

1961 Leaves Chicago to become head of the Department of Photography at The Rhode Island School of Design, Providence. Harry and Eleanor celebrate 25th wedding anniversary.

1964 First major monograph, *Photographs: Harry Callahan* published, which includes twenty-four photographs of Eleanor. Hallmark Cards, Inc. purchases 150 photographs for its permanent collection.

1965 Participates in White House Festival of the Arts. Eleanor works as secretary to the executive director of the Jewish Federation of Rhode Island for the next twelve years.

1967 Monograph *Harry Callahan* published by Museum of Modern Art, with fifteen photographs of Eleanor.

1970 One-man exhibition held at The Friends of Photography, Carmel, California.

1972 Receives Guggenheim Fellowship and National Association of Schools Award for distinguished contributions to teaching and photography.

1975 Archive purchased by the Center for Creative Photography, University of Arizona, Tucson. Includes personal papers, negatives, proofs and exhibition prints.

1976 Recognized as Honored Photographer at the annual meeting of the Society for Photographic Education. Retrospective exhibition at Museum of Modern Art, accompanied by a major monograph, *Callahan,* published by MOMA in association with Aperture. Book includes twenty-one photographs of Eleanor. Begins making new photographs exclusively in color, yet continues to print from his black-and-white negatives.

1977 Retires from a distinguished teaching career. Continues to travel and photograph extensively in foreign countries.

1978 One of two artists (with Richard Diebenkorn) chosen to represent the United States at the XXVII Venice Biennale. He is the first photographer to be so honored.

1979 Receives honorary Doctor of Fine Arts degree from the Rhode Island School of Design. Elected a fellow of the American Academy of Arts and Sciences.

1980 Receives first "Distinguished Career in Photography" award from The Friends of Photography's Peer Awards in Creative Photography Program. *Water's Edge*, published by Callaway Editions, includes four photographs of Eleanor. *Harry Callahan: Color*, published by Matrix Publications, includes two photographs of Eleanor.

1983 Granddaughter, Emily Erin, born March 16 to Michael and Barbara Callahan Hollinger. Harry and Eleanor divide year between Providence and Atlanta to be near their family.

1984 "Eleanor" exhibition opens at the Art Institute of Chicago, with a monograph published by The Friends of Photography and Callaway Editions. Harry and Eleanor celebrate 48th wedding anniversary.

Emily, Michael, Barbara, Eleanor and Harry

List of Plates

Colophon

Edition
17,000 Softcover Copies

Design
Nicholas Callaway and Anne Kennedy

Typography
Amy K. Reichert

Typesetting
David E. Seham Associates

Paper, Cover
Vintage Velvet 80lb Cover

Paper, Text
Mohawk Superfine 80lb Text

Duotone Printing
The Meriden Gravure Company

Binding
Mueller Trade Bindery

Production Director
Christopher E. Green

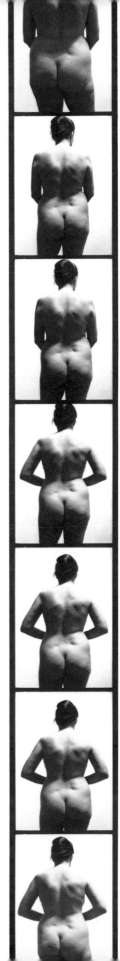

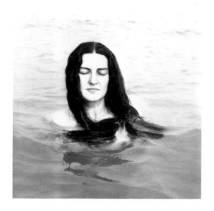

Published by

CALLAWAY
421 Hudson Street
New York, NY 10014
212-929-5212

THE FRIENDS OF PHOTOGRAPHY
Post Office Box 500
Sunset Center
Carmel, CA 93921
408-624-6330

This publication accompanies a traveling exhibition circulated by the Center for Creative Photography, University of Arizona at the following institutions:

January 18–March 14, 1984	**The Art Institute of Chicago,** Chicago, Illinois
March 30–June 24, 1984	**San Francisco Museum of Modern Art,** San Francisco, California
September 18–November 25, 1984	**The Detroit Institute of Arts,** Detroit, Michigan
January 15–March 17, 1985	**The Museum of Fine Arts, Houston,** Houston, Texas
September 8–October 27, 1985	**The Snite Museum,** University of Notre Dame, Notre Dame, Indiana
January–February 1986	**Center for Creative Photography,** University of Arizona, Tucson, Arizona

Callaway Trade Edition: ISBN 0-935112-11-1 Library of Congress Catalogue No. 83-71130

Library of Congress Cataloging in Publication Data
Callahan, Harry M.
 Eleanor.

 1. Photography—Portraits. 2. Callahan, Eleanor.
3. Callahan, Harry M. I. Title.
TR680.C27 1983 779'.24'0924 83-71130
ISBN 0-935112-11-1